THE

# PAINTBRUSH
# PLAYBOOK

44 Exercises for Swooshing, Dancing,
and Making Dazzling Art With Your Brush

## ANA MONTIEL

**Quarry Books**
100 Cummings Center, Suite 406L
Beverly, MA 01915

quarrybooks.com • www.craftside.net

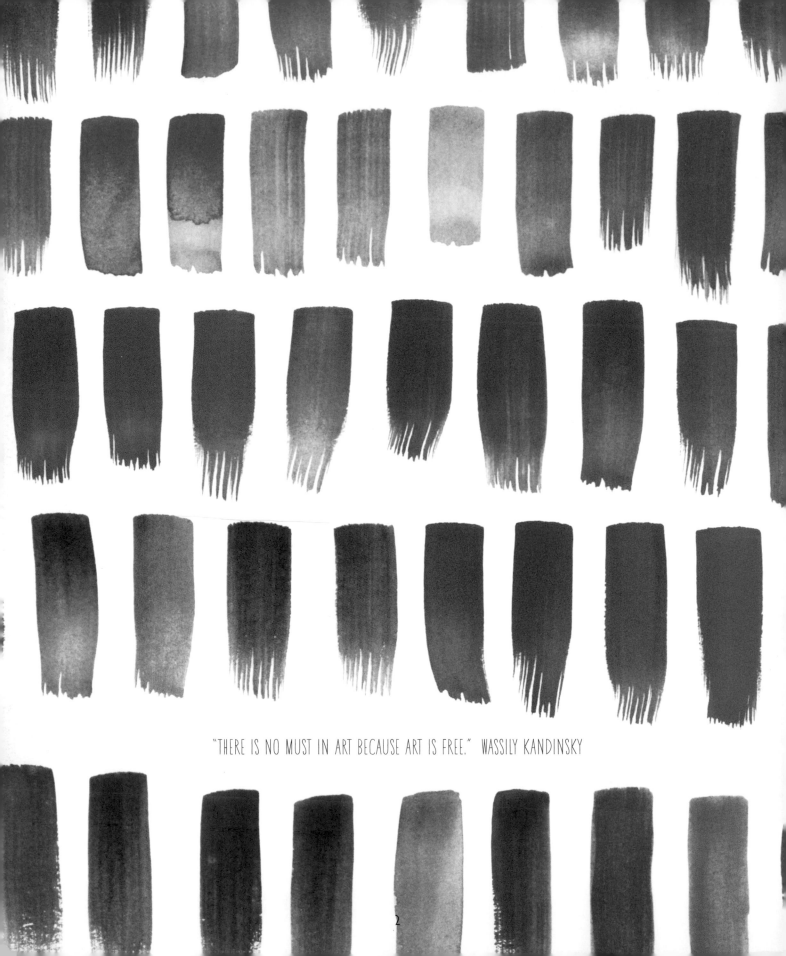

"THERE IS NO MUST IN ART BECAUSE ART IS FREE."  WASSILY KANDINSKY

# CONTENTS

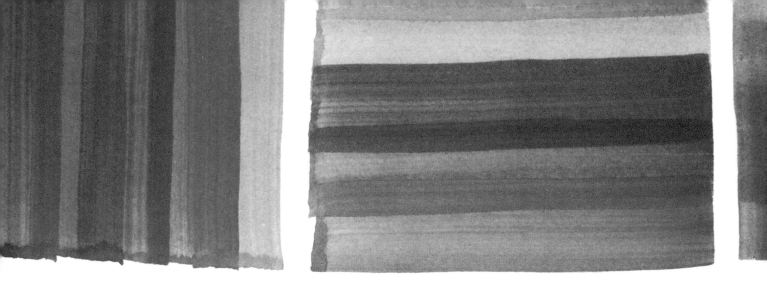

"TO PRACTICE ANY ART, NO MATTER HOW WELL OR BADLY,
IS A WAY TO MAKE YOUR SOUL GROW. SO DO IT." KURT VONNEGUT

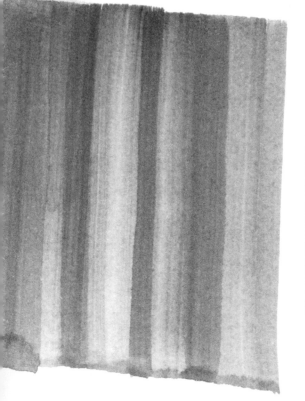

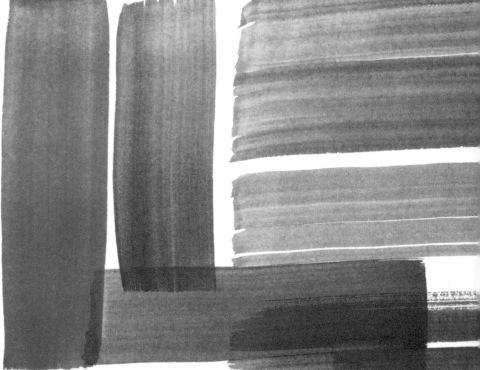

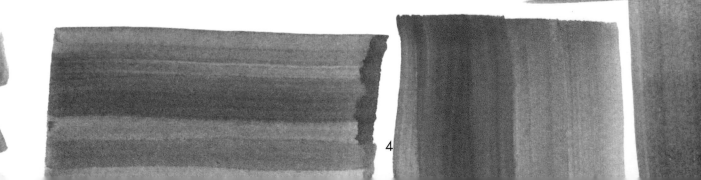

Thank you for choosing this book. I'm very happy to have you here.

Inside this playbook, you'll find exercises that are intended to work as explorations in various water-media techniques. I provide instructions and tips, but feel free to experiment in different ways and follow your intuition. The key is to have fun with our paintbrushes and colors!

The artwork doesn't have to look great all the time, nor does it have to be too detailed or representational. What matters is enjoying the creative process and taking incremental steps toward a more colorful life. Creativity has to be free and never is to be judged. Everything has a place in this world, even the things you may consider ugly may seem beautiful to another person!

Painting and drawing can be the kinds of activities that help you focus on the present moment and allow you to tap into your inner wisdom to find some insight. For me, they are like meditating. When we turn off our rational brain for a bit, we can start getting in touch with our wildly creative subconscious mind. This is one of the powers of art.

Be inspired, play, paint—make a mess if you may—clean and repeat. Forever.

Yours in color and shape,

# COLOR CHART

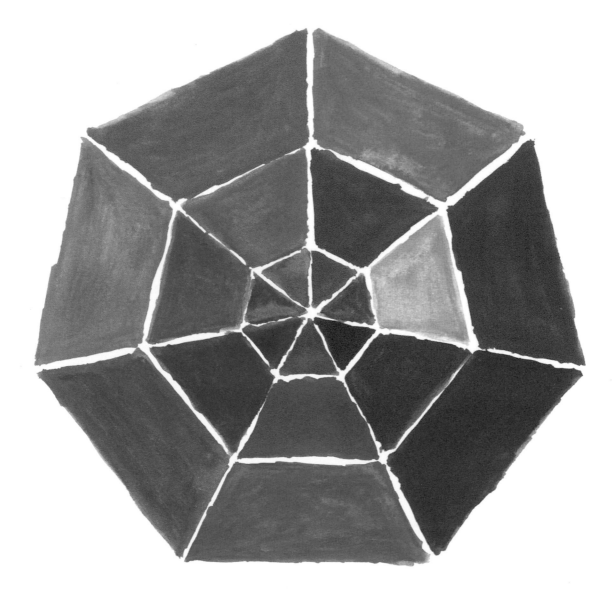

You don't need to buy more than five colors to achieve endless hues and shades. Investing in good quality white, yellow, magenta, cyan (also known as process blue), and black paints will go a long way. Try mixing some of these five colors and select your favorite hues to make your personal color chart. Mix tiny quantities at first and write down the formulas of your favorite combinations so you can replicate them in the future.

**TIP:** TO MAKE A CLEAN AND CHROMATICALLY HARMONIOUS CHART, EXPERIMENT WITH YOUR COLOR COMBINATIONS ON SEPARATE PIECES OF PAPER AND THEN CUT, ARRANGE, AND GLUE THE ONES YOU LIKE MOST INTO A WHEEL/CHART.

# GRADIENT WASHES

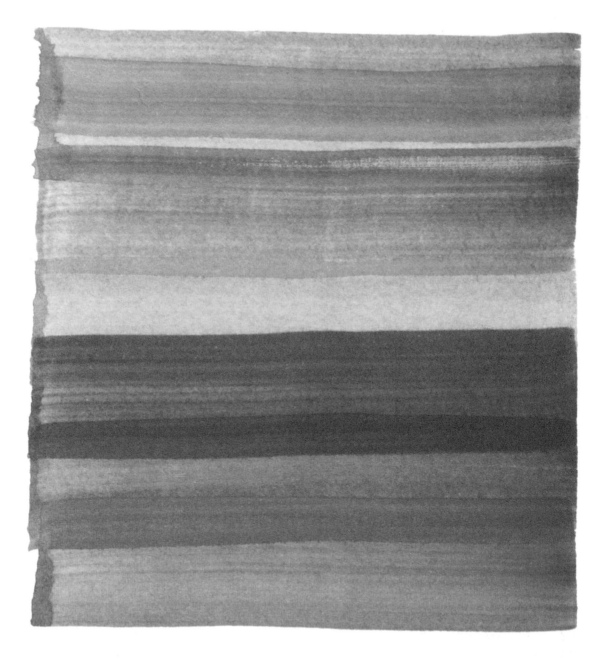

Choose a color. Dip a flat brush in water and then load up the brush with the color. Make a brushstroke with it. Clean your brush in clear water and choose a different hue and immediately apply another stroke, overlapping half of the previous one. Repeat the previous steps with as many tones as you like to achieve a gradient effect, cleaning your brush each time before using a different color.

**TIP:** THE MOST IMPORTANT THING FOR THE GRADIENT TO LOOK SMOOTH IS TO APPLY THE WATERCOLOR WASHES QUICKLY SO THEY CAN MIX A LITTLE BEFORE DRYING.

# BLOBS INTO CHARACTERS

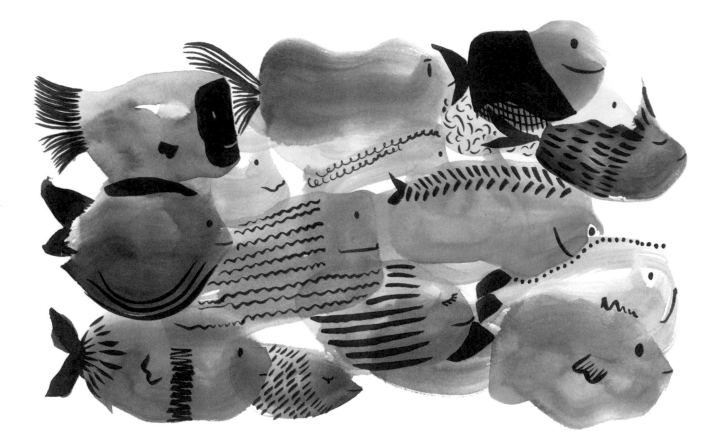

This exercise is a bit like watching clouds and figuring out what they look like. Pick a big round brush and start making some blobs. Look at the blobs and ask yourself what they could be. Let your mind wander—could they be trees or animals or macaroons? Once you decide, pick a fine tip brush and draw some details on top of the blobs. Here, for example, I added fins, scales, and eyes with black ink to form a school of fish.

**TIP:** YOU CAN WORK WITH DIFFERENT COLORS OR STAY WITH A RESTRICTED PALETTE AS I DID. ALSO, YOU CAN TRY MAKING SHAPES WITH STRAIGHT EDGES—THEY DON'T ALL HAVE TO BE ROUNDED. YOUR BLOBS CAN BE ANYTHING THAT YOU WANT!

# COLOR LAYERING

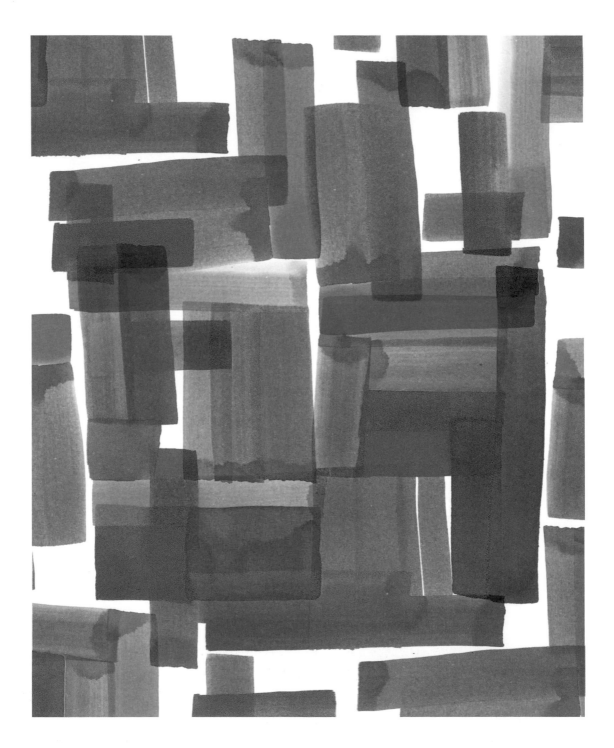

PAINT
HERE

Layering washes can give depth to your chromatic palette and interest to your compositions. Apply the color with a flat brush (any other brush will work too!) on top of the dry paper. Let the watercolor dry and then afterward, layer a new shade on top of it. Repeat with as many colors as you like.

**TIP:** TRY TO BE QUICK WHEN LAYERING ANY NEW COLORS SO THE MARKS OF EACH OF THE BRUSHSTROKES STAY CRISP AND CLEAN.

# INK FLOWERS

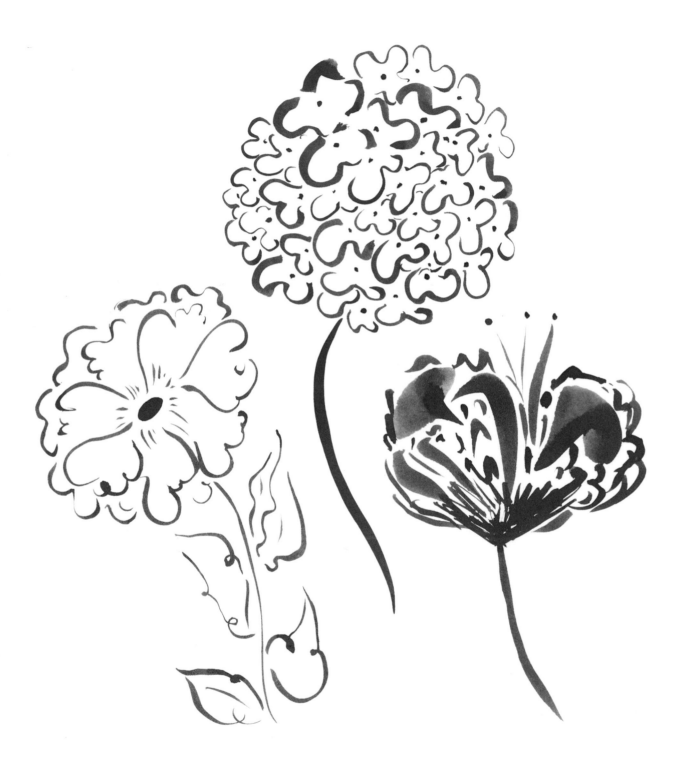

For this kind of line work, I recommend using a water brush (such as the Pentel ones). You can create a mix of liquid watercolor or ink inside the brush itself and draw with it nonstop as if it was a marker. Look at a flower and study its curves and shadows—you don't have to represent it realistically, just make an interpretation.

**TIP:** EXPERIMENT WITH THE STROKE. FOR EXAMPLE, TRY PAINTING SOME FLOWERS IN A MORE EXPRESSIVE WAY, OTHERS WITH A SOFTER, MORE CALLIGRAPHIC APPROACH, OR GO MINIMAL—JUST A STEM AND COLOR BLOB COULD GIVE A FLORAL IMPRESSION.

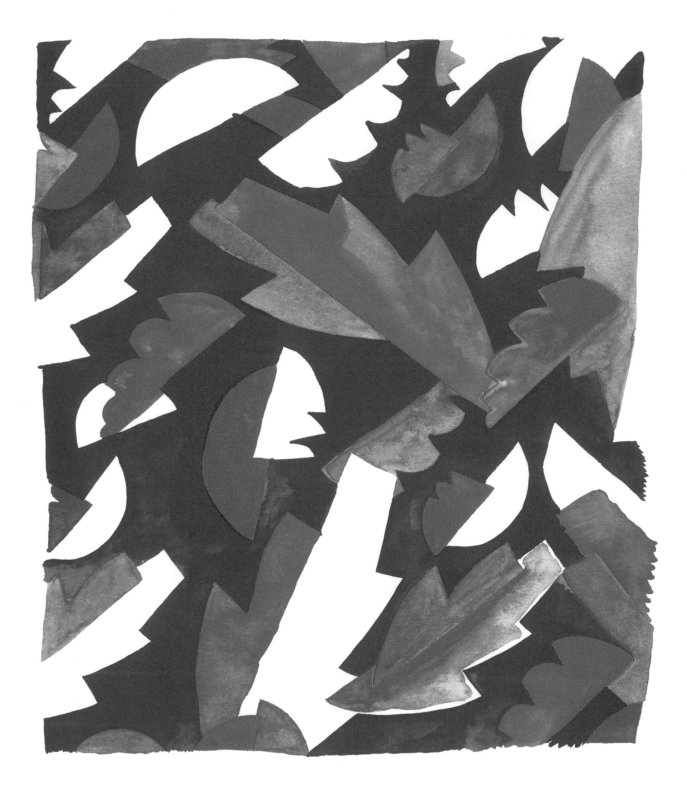

PAINT
HERE

This composition is made of repeating pieces. Cut some card stock into a few simple shapes and place them randomly in different positions on top of your drawing paper. Trace the silhouettes with a pencil. When you are happy with the layout, start coloring with paint, such as watercolor, and then erase the pencil afterward.

**TIP:** VIBRANT COLORS ARE UPLIFTING AND RESONATE WITH OUR INNER CHILD. DON'T BE AFRAID OF BEING BOLD WITH YOUR COLOR SELECTION. BRIGHT IS RIGHT.

# HAND AS TEMPLATE

PAINT HERE

Tracing our hands is in our primeval nature, but something as basic as this can take you to unexpected and interesting places. Connect with your body, channel your inner child, and play with composition, repetition, textures—the sky is the limit!

**TIP:** TRACE YOUR HANDS FIRST WITH A PENCIL AND THEN AFTERWARD REDRAW THEM WITH YOUR BRUSH. OR YOU COULD USE A WATER SOLUBLE COLOR PENCIL THAT DISSOLVES WHEN YOU APPLY PAINT ON TOP OF IT.

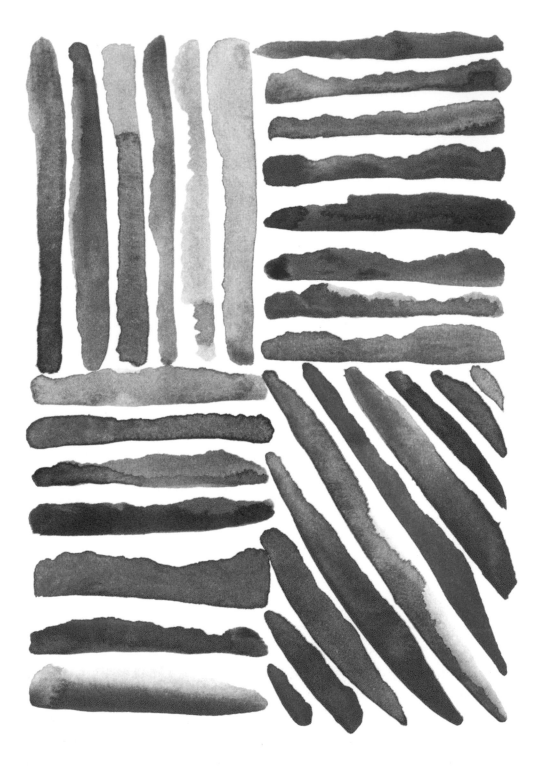

PAINT HERE

Watercolor offers endless blending possibilities to achieve different hues and gradients. Make a brushstroke in one hue and then apply a second or third color with the tip of your brush when the paint is still wet. A filbert or a round brush will work well for this.

**TIP:** BLOWING THROUGH A STRAW OR GENTLY BENDING THE PAPER WILL HELP YOU DIRECT THE BLENDING OF THE COLORS. YOU CAN ALSO DRIP A WATER DROP ON TOP OF THE PAINT TO BRING MORE MOVEMENT.

# SCRIBBLING

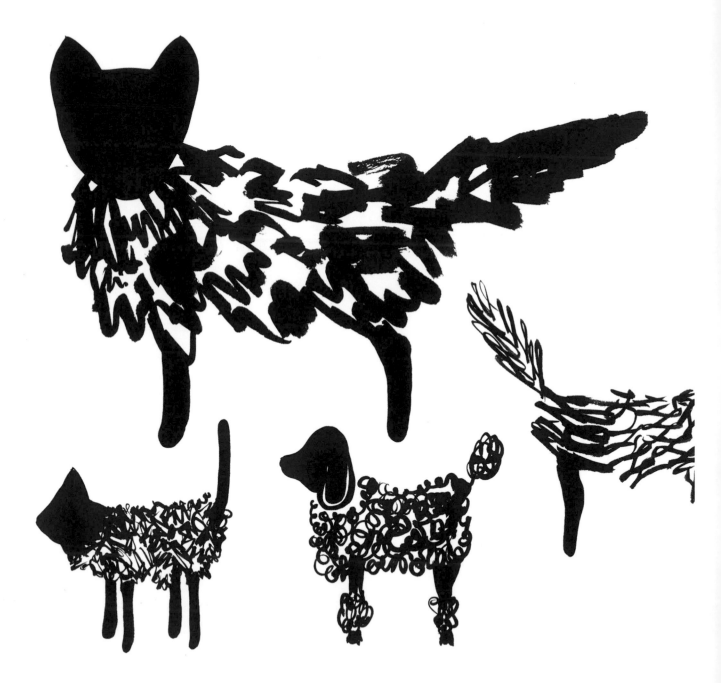

For this exercise, you can choose animal silhouettes or something more abstract. Start by making a simple pencil sketch of your drawing. When done, start scribbling and filling in the shapes with ink and a round brush. When the ink is dry, you can erase the pencil marks. Don't think—just paint and have fun!

---

**TIP:** TRY A CIRCULAR MOTION TO GIVE A CURLY FEEL OR AN EDGIER, ZIGZAG MOVEMENT FOR STRAIGHT HAIR. JUST MOVE YOUR BRUSH AROUND IN A REPETITIVE WAY AND SEE WHAT YOU COME UP WITH!

# ALL-OVER PATTERN

1.

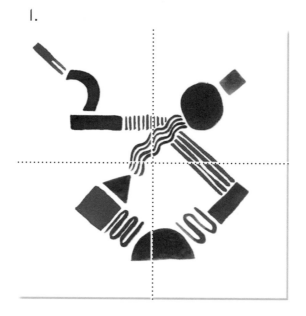

2.

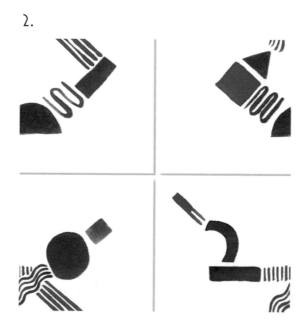

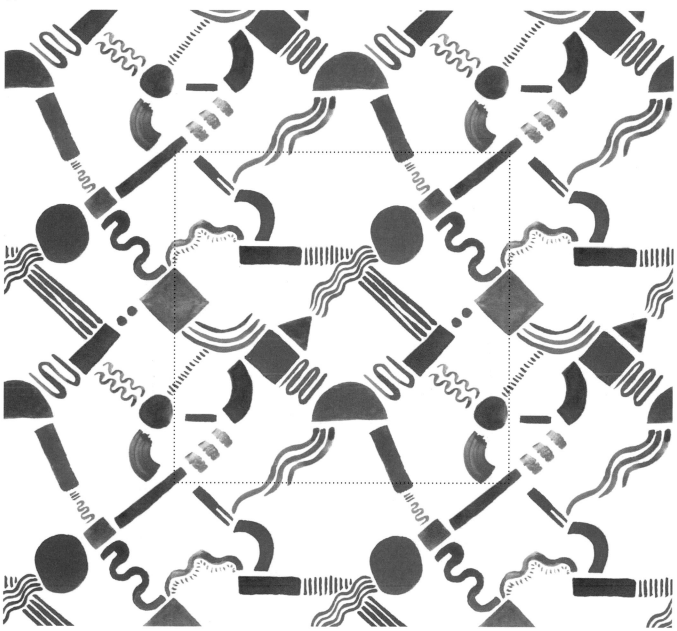

**1.** On a separate piece of paper, create a drawing and leave a wide margin of blank space around it. Using a ruler, divide the paper into four equal parts. **2.** Cut out the four parts and rearrange them (the ones on the right move to the left and the bottom ones move to the top). Join them by applying tape to the reverse side of the paper. **3.** Complete your drawing by filling in the blank areas however you want and say hello to your repeat module!

---

**TIP:** FOR YOUR FIRST PATTERNS, YOU MAY WANT TO USE AN IMAGE EDITING SOFTWARE FOR THE REPEAT TO BE SEAMLESS, BUT WITH PRACTICE, THE EDGES WILL LOOK MUCH CLEANER AND WON'T NEED RETOUCHING.

# WATER FLIES

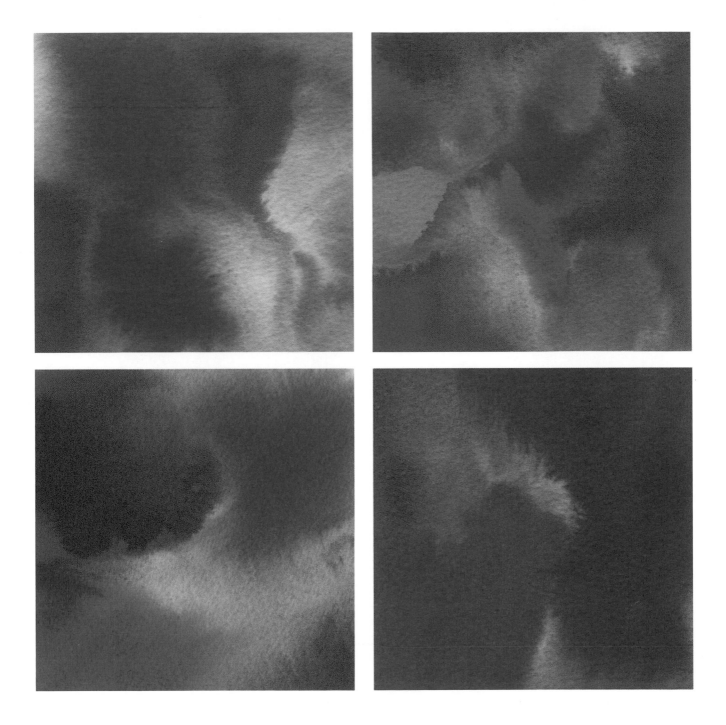

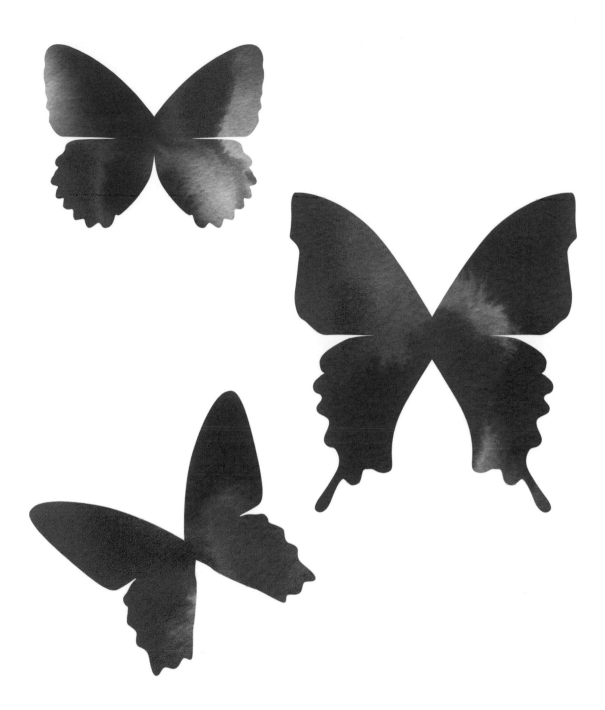

Using a brush, wet some watercolor paper and scatter a few drops of watercolor paint on it. Blow on the paper with a straw to mix the colors and form gradients. After leaving the paper to dry, fold it in half and draw a butterfly wing on one side, starting from the folded edge. Cut the paper following your drawing, unfold, and admire your first water fly!

**TIP:** FOR YOUR PAPER TO STAY SMOOTH AND AVOID ANY WARPING, TRY SECURING ITS MARGINS TO YOUR WORKING SURFACE WITH PAINTER'S TAPE. REMOVE THE TAPE CAREFULLY WHEN DONE SO AS NOT TO DAMAGE YOUR ARTWORK.

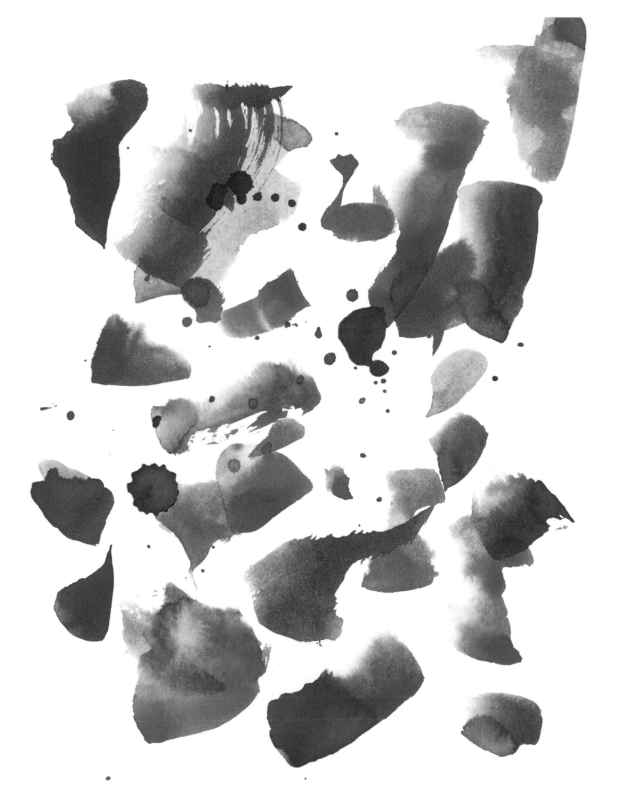

PAINT
HERE

It's good to listen to music or something you like and enjoy while doing this exercise. Keeping your rational brain busy is key to letting your inner child play with colors, drippings, and random strokes without judging the results. Experiment and have fun!

**TIP:** START WITH THE LIGHTER HUES AND THEN GRADUALLY CONTINUE WITH THE DARKER ONES. THAT WAY, YOU WON'T HAVE TO CHANGE THE WATER IN YOUR GLASS AND CLEAN YOUR BRUSH EACH TIME YOU CHANGE COLOR.

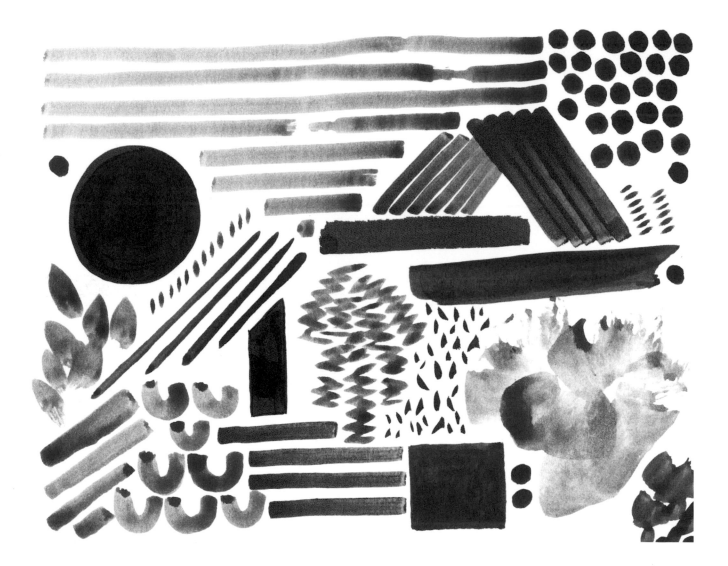

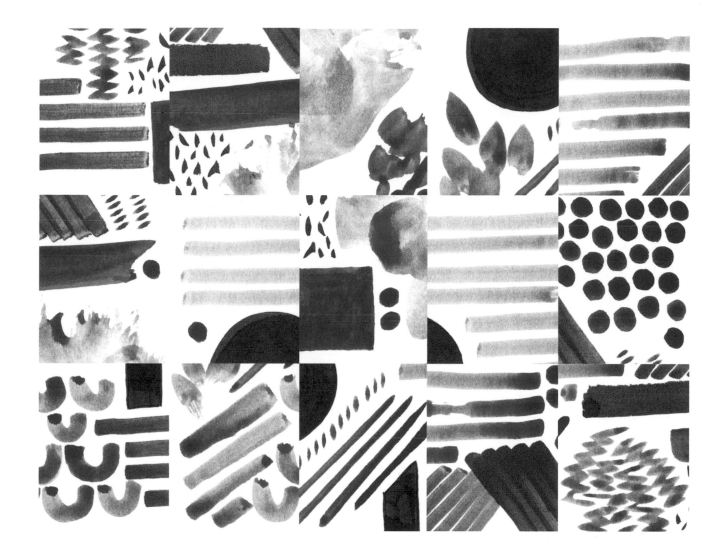

Leaving some things up to fate can result in a nice surprise. Play with the unexpected in this exercise by first making a painting—whatever comes to mind. Then divide it into a grid and cut it into evenly sized squares. Rearrange the pieces at random and see what you get! If you like the results, glue them to a new sheet of paper.

**TIP:** YOU DON'T HAVE TO CUT THE PAINTING INTO SQUARES AND FORM A GRID. EXPERIMENT WITH OTHER SHAPES, SUCH AS TRIANGLES, BARS, OR ANYTHING YOU WANT—AS LONG AS THEY WILL FIT TOGETHER AGAIN!

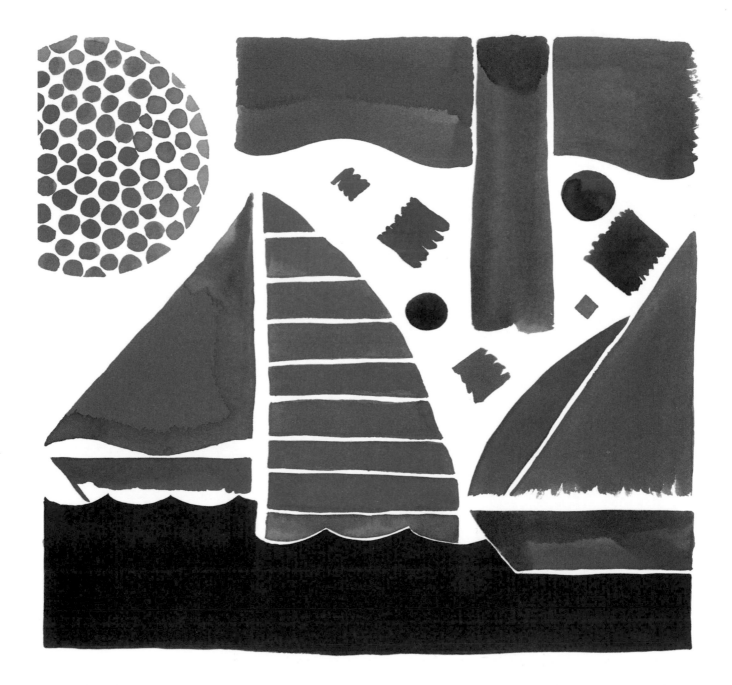

For this exercise, focus on sailboat shapes and the sea. Don't be afraid of going too abstract. Keeping the color palette to greens and blues will give the composition that maritime feel. Color is powerful and evocative!

**TIP:** FOR THE BEST RESULT, USE A MEDIUM ROUND BRUSH FOR THIS EXERCISE. USE IT VERTICALLY FOR THE SMALLER SHAPES, LIKE THE CIRCLES, AND TILTED TO COVER BIGGER SURFACES, LIKE THE SEA.

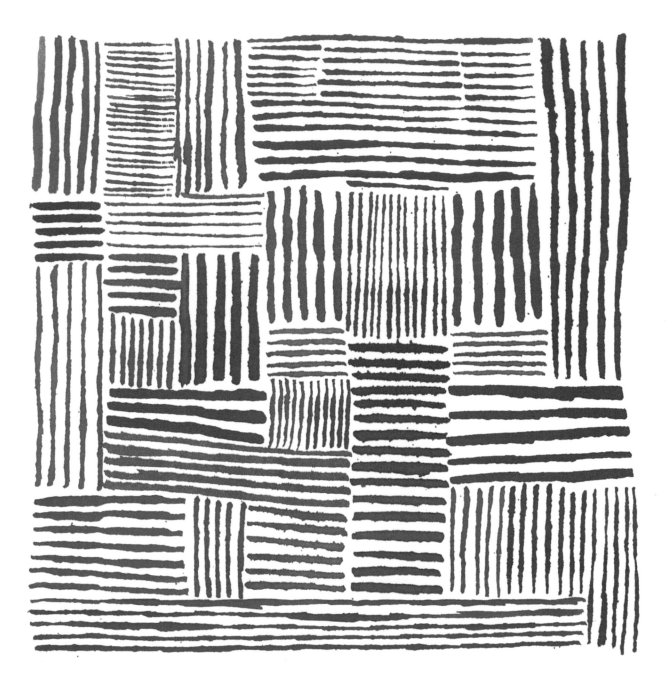

For this exercise, use three flat brushes of different lengths and thicknesses. Hold them vertically, perpendicular to the paper, and lightly touch the tips on the page to form parallel lines. Use the brushes as if they were stamps and gradually build up a pattern. Don't plan ahead too much; instead, improvise and see what happens.

**TIP:** TRY REPEATING SOME COLORS IN THE COMPOSITION TO GIVE IT SOME RHYTHM. ALSO, YOU CAN TRY CROSSING SOME OF THE MARKS FOR IT TO HAVE A MORE "PLAID" LOOK OR GO ALL CRAZY AND MAKE MARKS IN ALL ANGLES!

# MINIMAL PORTRAIT

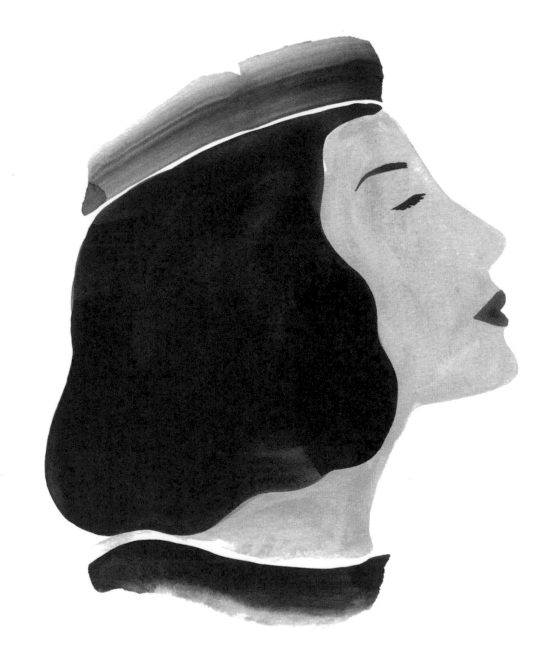

Closing your eyes to blur your vision a little will help you ignore minor details and focus on the key features of what's in front of you. Try this to make a simple portrait. Address a couple of main shapes first, such as the head or hair. Then add a couple of features, such as the eyes and lips. Draw first with pencil and then paint with acrylic.

**TIP:** TO GIVE AN ACRYLIC OR GOUACHE COMPOSITION MORE LIGHTNESS, TRY BALANCING IT WITH A TOUCH OF WATERCOLOR OR INK. I USED THE LATTER FOR THE HAT AND THE COLLAR SO THAT THEY LOOK MORE DELICATE.

# FRISKET AND COLLAGE

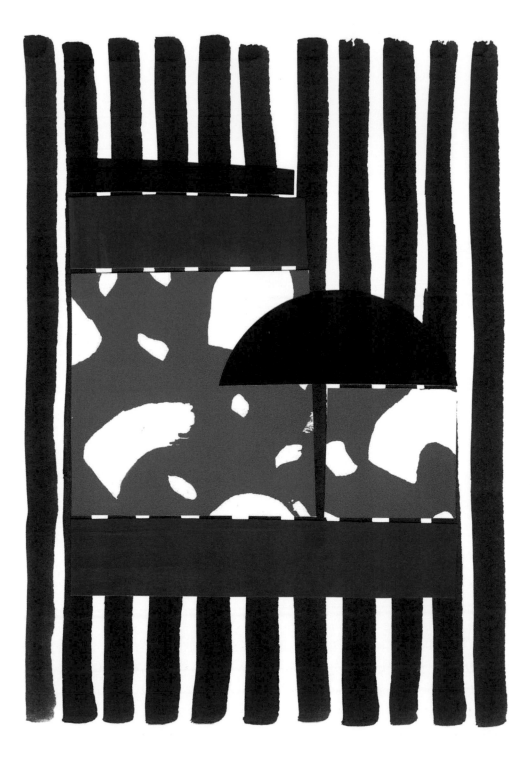

Apply liquid frisket to mask out white shapes, such as those that appear on the yellow areas. After the frisket is dry, paint the surface with yellow watercolor. When the color is dry, remove the frisket by rubbing it with clean hands. To finish, paint solid navy and black shapes with gouache. Add stripes to the background with ink and a flat brush.

**TIP:** ALWAYS APPLY LIQUID FRISKET WITH AN OLD BRUSH OR SOMETHING ELSE YOU DON'T MIND GETTING RUINED. ITS GUMMY TEXTURE TENDS TO TRANSFORM GOOD BRUSHES INTO VERY RAGGED ONES!

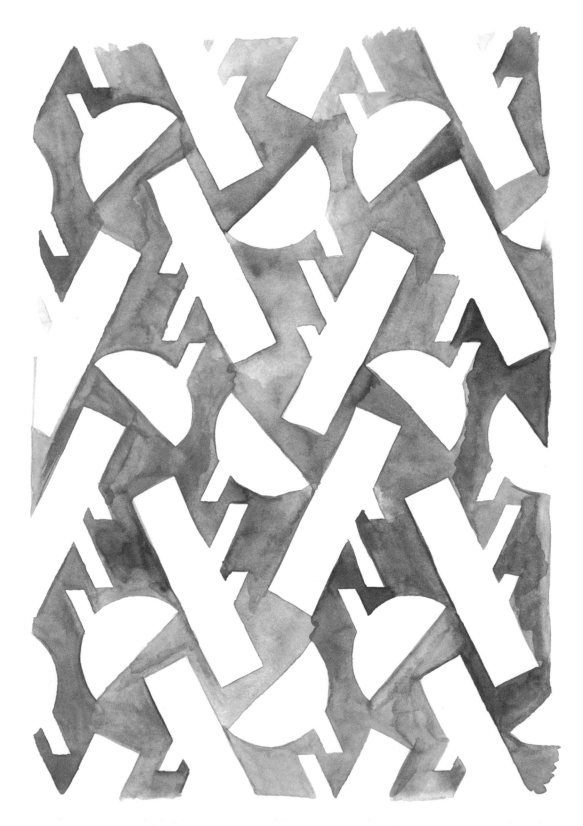

Cut several shapes out of thick paper or cardboard. Then trace their contours repeatedly with a pencil, creating a pattern on paper. When you are happy with the composition, start covering the background with watercolor or acrylic paint to let the white shapes you outlined pop.

**TIP:** WHEN PLACING AND ARRANGING THE PAPER TEMPLATES YOU HAVE CREATED ON THE PAPER, PLAY WITH FLIPPING THEM HORIZONTALLY AND VERTICALLY AND ROTATING THEM FREELY. THE COMBINATIONS ARE ENDLESS!

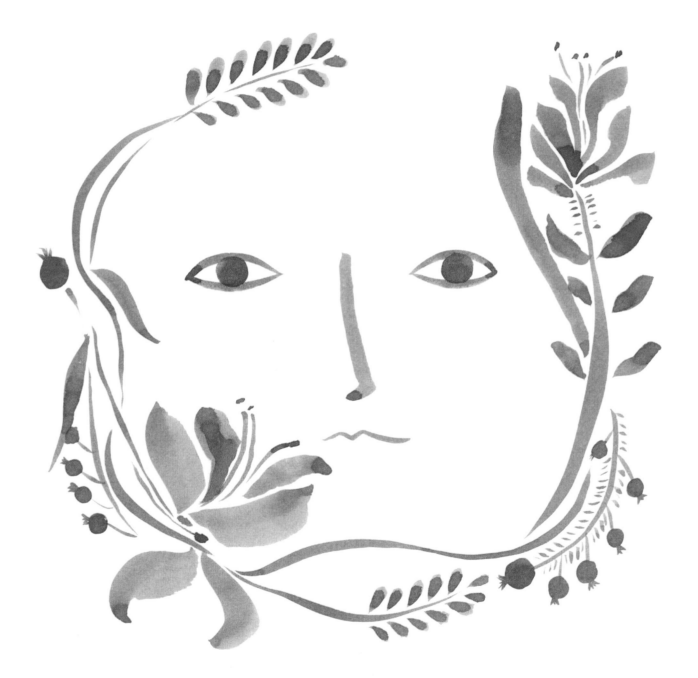

PAINT HERE

Make the leaves in a wreath by pressing different brushes flat against the page. Each brush will give you a different shape. Use short brushes for tiny rounded leaves and long brushes for grasses and stems. You can also tilt different brushes for diverse results.

**TIP:** THIS EXERCISE IS MONOCHROMATIC BECAUSE I WANTED TO FOCUS ON THE SHAPES, BUT FEEL FREE TO APPLY AS MANY COLORS AS YOU WANT. FOR EXAMPLE, THIS WOULD LOOK GREAT WITH A YELLOW, MUSTARD, OCHRE, AND RED PALETTE!

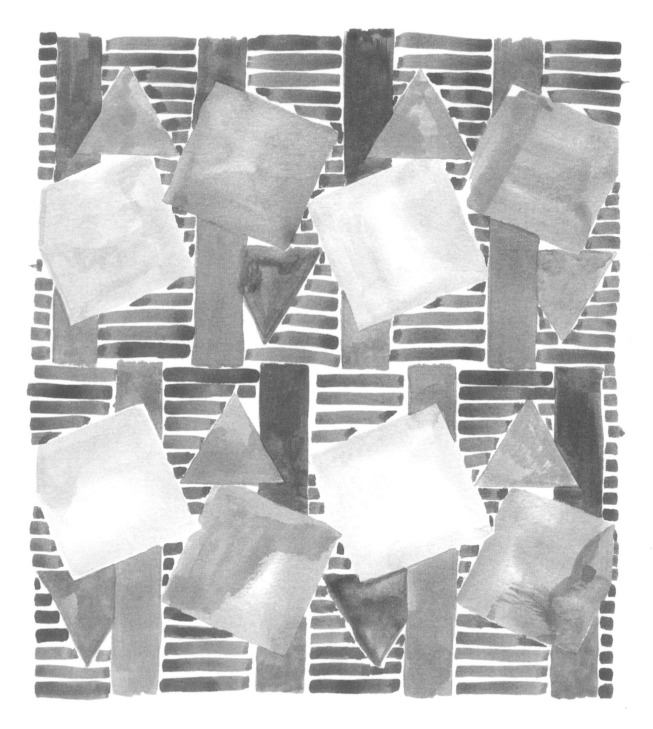

PAINT HERE
↘

To create a modular pattern like this, draw it on paper. Using carbon paper, trace it many times on the same sheet of paper, side by side. Use a light-colored carbon paper for the outlines so as not to be too obvious when covering with color afterward.

**TIP:** YOU CAN MIX SUBTLE, MORE COMPLEX COLORS BY ADDING BLACK AND/OR WHITE TO THE MAIN COLOR COMBINATION, SUCH AS THE YELLOW AND BLUE. BE CAREFUL WITH BLACK AS A DROP CAN BE MORE THAN ENOUGH.

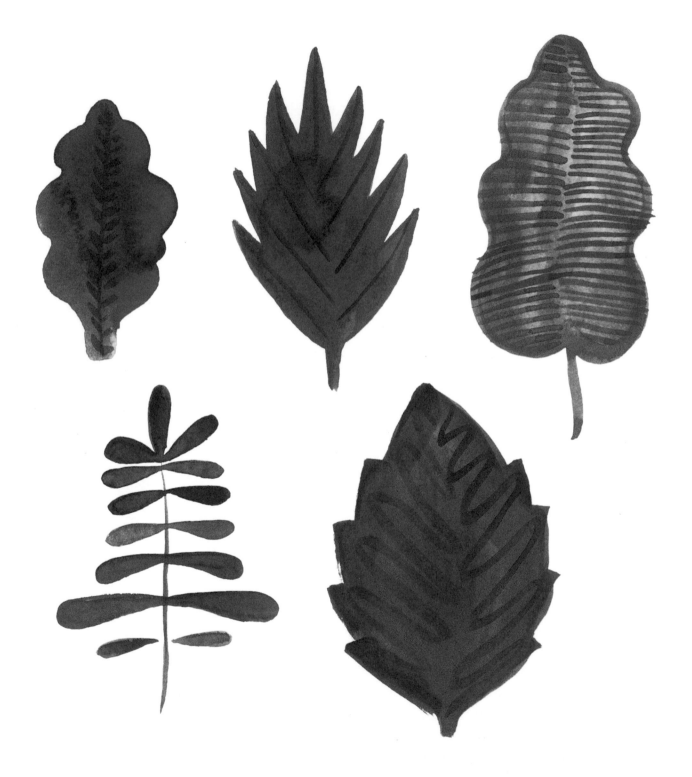

Go for a walk and examine the leaves on the trees and plants you encounter. Make a composition by drawing the ones that caught your attention. Notice the different sizes, shapes, and colors and be as accurate or abstract as you like. The ones on the opposite page were done with watercolor and a medium-size round brush.

**TIP:** IF YOU WANT TO EXPLORE LEAF PATTERN DESIGNS, CHECK SOME VARIETIES OF CALATHEA PLANTS OR NASTURTIUM ALASKA MIX FOR INSPIRATION. THEIR DESIGNS ARE GORGEOUS!

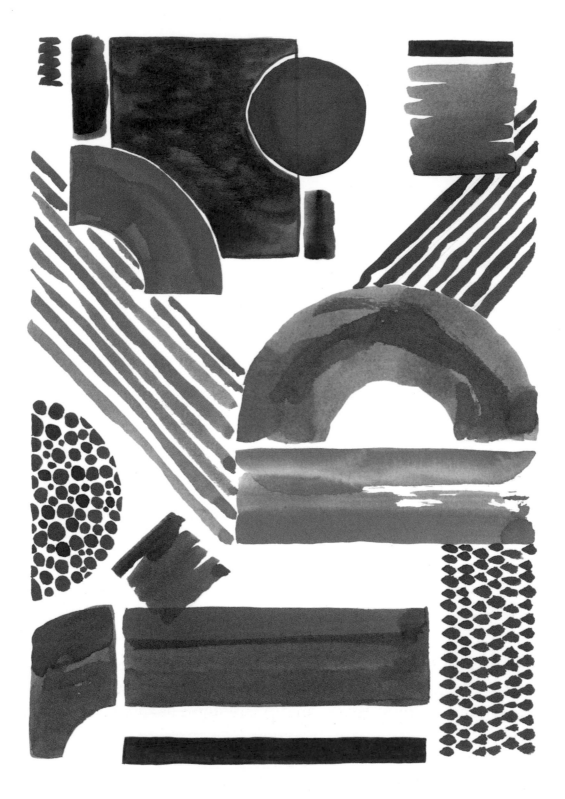

Balance in a composition is very important. Start by painting simple geometric shapes and add tension and movement by joining them together with diagonal elements. Try using a combination of filbert, round, and flat brushes for this exercise to form the different shapes.

**TIP:** USE A MIXTURE OF INK AND WATERCOLOR FOR THIS EXERCISE, ADDING A SMALL AMOUNT OF BLACK TO MOST OF THE HUES FOR AN OVERALL MUTED PALETTE.

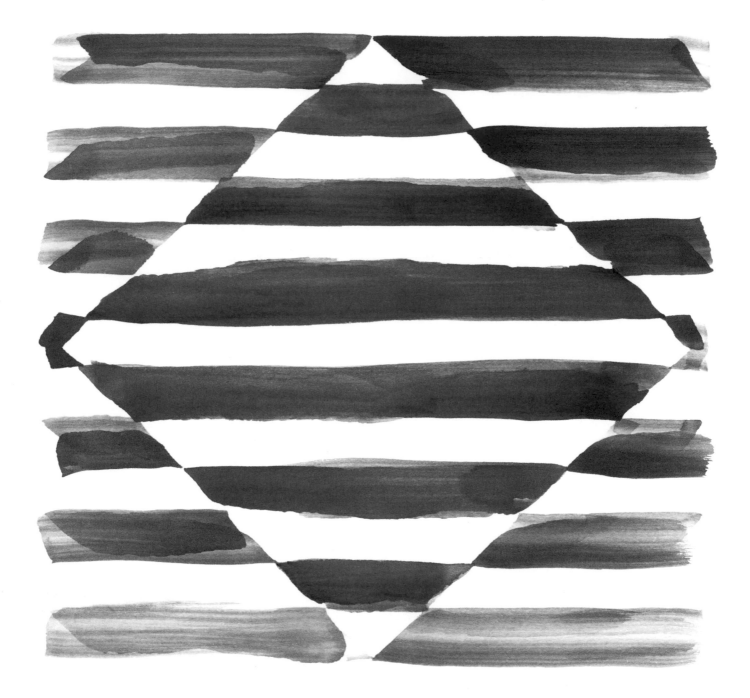

Draw a square. Draw a line from the center of each side to the next side until you've created another square inside of the first square. Divide both squares into horizontal bars measuring the same size. Now apply a watercolor hue on alternate bars of the inner square and paint the opposite bars of the outer square in a different shade. I used a dagger brush, but any other brush would be fine.

**TIP:** FOR A MORE VIBRANT RESULT, YOU COULD PLAY WITH COMPLEMENTARY COLORS, SUCH AS RED AND GREEN OR BLUE AND YELLOW SO THAT THE OPTICAL EFFECT AND CONTRAST IS BOLDER.

# TOOTHBRUSH SPLATTER

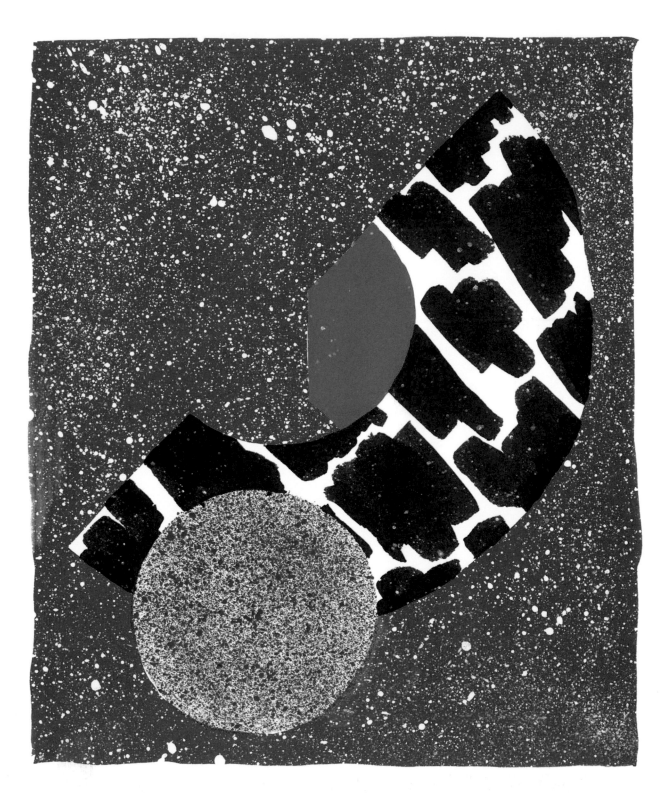

Apply a red background with acrylic paint. Then dip an old toothbrush in white paint, hold it over the paper with the bristles facing down and slide your finger along its bristles to release the splatter. You can apply ink with a round brush to make the black areas so that the splatter texture shows through.

**TIP:** YOU CAN COVER SOME AREAS WITH MASKING TAPE OR PAPER PIECES TO PROTECT THEM FROM BEING COVERED WITH THE TEXTURE. THIS WAY, YOU'LL BE ABLE TO HAVE A WIDE RANGE OF SURFACE FINISHES.

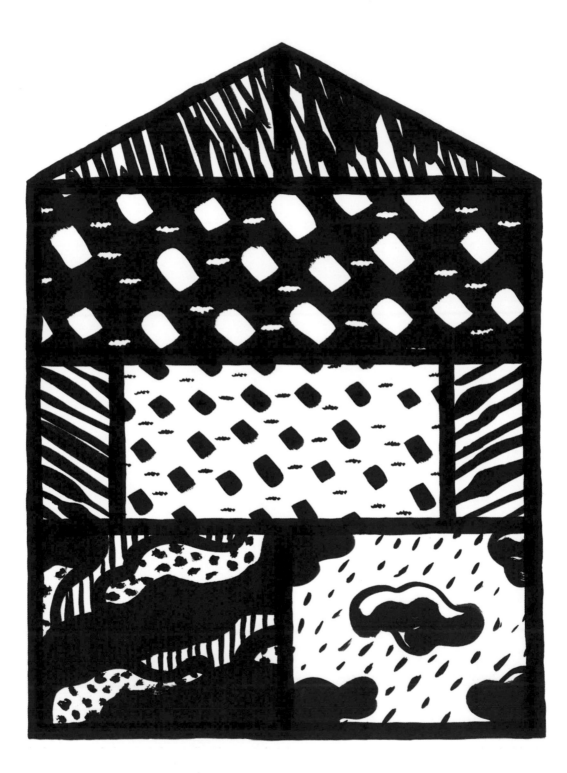

Using a flat brush and ink, draw a house structure. Decide which areas are going to be black on white and white on black. On the latter ones, apply liquid frisket to mask the white areas. On the rest, start testing different textures with ink and different brushes.

**TIP:** SKETCH WITH A PENCIL FIRST TO PLAN THE TEXTURES, SHAPES, AND DIFFERENT INK AREAS. IF YOU WANT TO MAKE MORE FLUID AND CALLIGRAPHIC INK TEXTURES, TRY USING A WATER BRUSH.

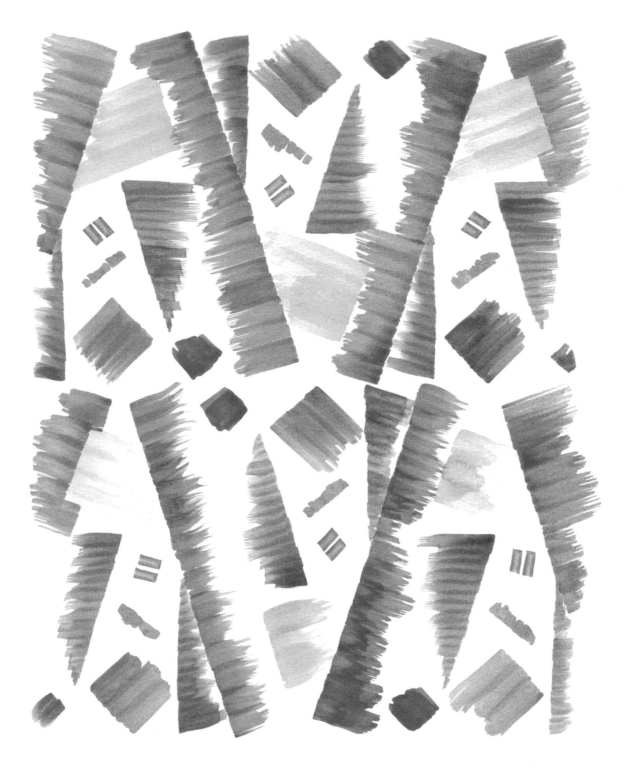

Repetition has a soothing mantric quality but also a vibrant rhythmic undertone. You can draw the structure for this exercise with pencil and erase it after applying the watercolor (or simply skip the pencil part). Try avoiding square angles while planning your composition to infuse it with movement.

**TIP:** TO GIVE YOUR PAINTING A LOOSE, FRESH LOOK, USE FLAT BRUSHES WITH WATERCOLOR AND KEEP YOUR STROKES SWIFT AND ENERGETIC.

# NOCTURNAL BOTANIC

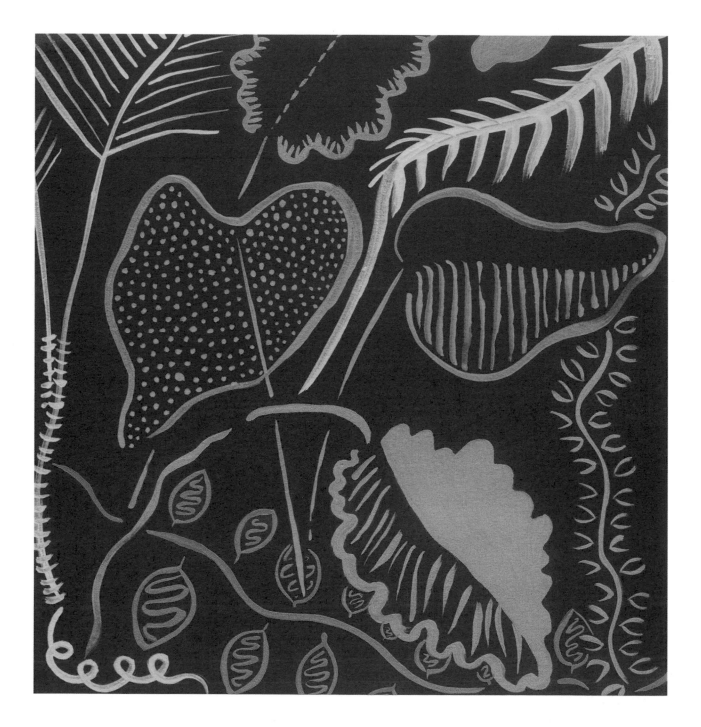

Acrylic and gouache can be very opaque. This comes in handy when you need to paint over a dark background. After painting a dark background, try making simple shapes, such as botanical or any other kind, and familiarize yourself with the density of the paint.

**TIP:** USING PALE OR MUTED COLORS OVER A DARK BACKGROUND CAN GIVE ANY ARTWORK A NIGHTTIME FEEL. YOU CAN TAKE ADVANTAGE OF THIS AND EMBRACE A NOCTURNAL THEME (SUCH AS STAR CONSTELLATIONS OR A NIGHT LANDSCAPE).

# RUSSIAN DOLLS

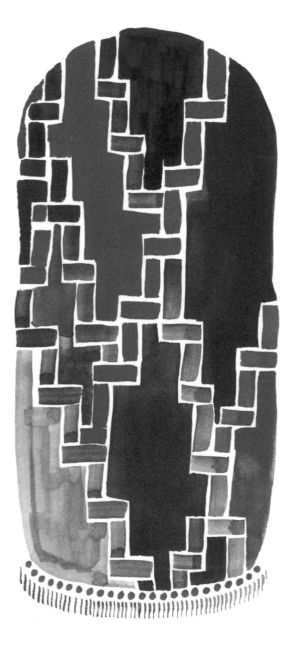

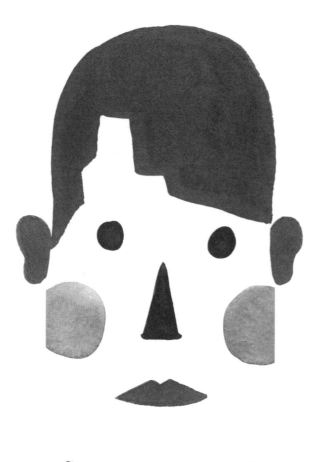

There are so many ways to decorate Russian dolls! Abstract, figurative, colorful, monochromatic—try different techniques and see what happens! The ones on the opposite page were done with ink and watercolor using flat and round brushes.

---

**TIP:** FEEL FREE TO EXPLORE DIFFERENT THEMES. PLAY WITH LETTERS AND NUMBERS, TRY PAINTING EACH OF THE DOLLS WITH JUST ONE COLOR, TURN THEM INTO DIFFERENT ANIMALS—THE POSSIBILITIES ARE ENDLESS!

# MANDALA

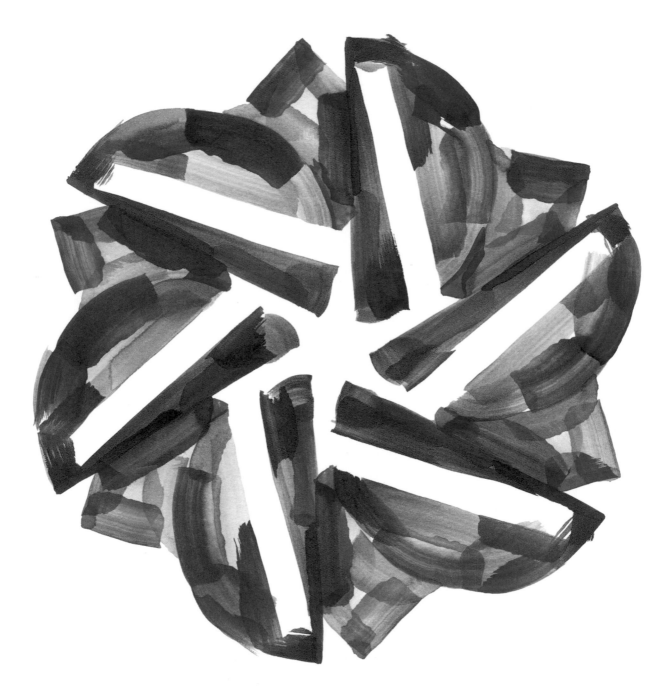

Use a pencil to sketch out a large asterisk shape. This will form the axes of your mandala. Draw a few shapes along one of the axes, either freehand or with the help of a ruler or template. Copy the shapes on the other axes to create a repeating pattern and color freely. When the paint is dry, simply erase the pencil structure.

**TIP:** REPLICATING THE SAME HUES ON EACH OF THE DIFFERENT AXES WILL HELP THE MANDALA ACHIEVE A RHYTHMIC, REPETITIVE FLOW. TO APPLY THE WATERCOLOR, USE A DAGGER BRUSH, WHICH IS GREAT FOR CAPTURING MOVEMENT, AND A FLAT BRUSH.

# BRUSH MARKS

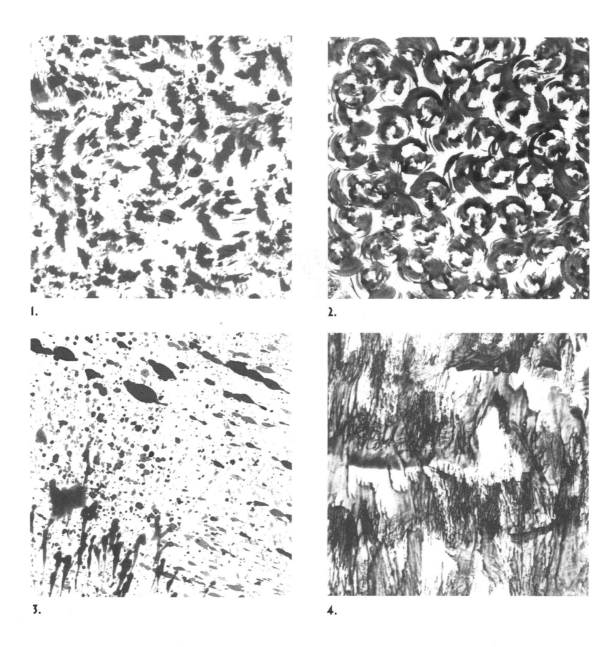

1.

2.

3.

4.

Try and see how many different textures you can achieve with your brushes. The examples on the left represent the following: **1.** A thick round brush tip dabbed across the paper. **2.** A round hard brush spun on its axis. **3.** A medium round brush shaken to spread drips of paint. **4.** A round brush turned on its side and spun across the paper.

**TIP:** FOR THE SPLATTER TO BE MORE DIRECTIONAL AND LESS MESSY (SEE NUMBER 3), YOU CAN TAP YOUR BRUSH AGAINST A FINGER FOR IT TO RELEASE THE PAINT. USE A SOFT, THICK BRUSH FOR LARGER SPLATTER AREAS.

# LINEAR MEDITATION

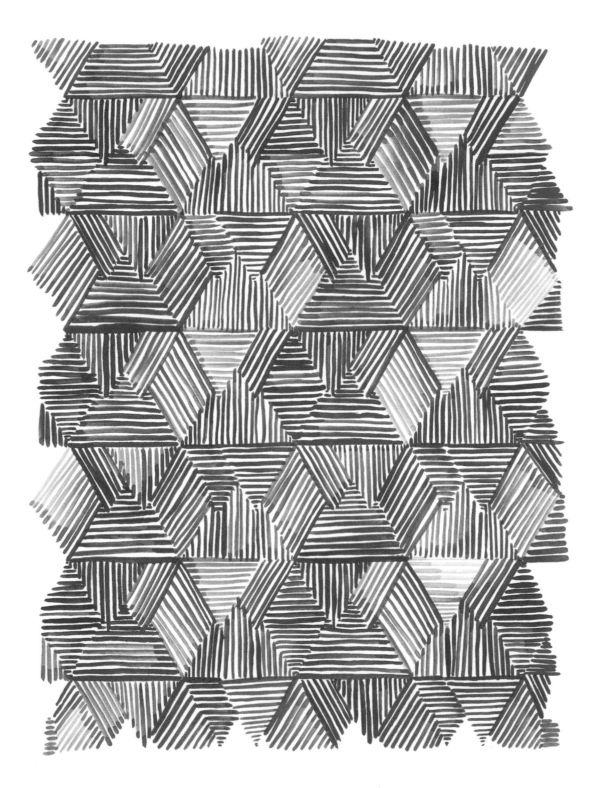

Repetition and rhythm can keep our "inner censor" busy while we focus and connect with our activity. This exercise can help with that. You can draw a structure with pencil and then fill it with colored lines, but feel free skip that step and start with watercolor directly. Just go with the flow and enjoy the rhythm!

**TIP:** FOR ADDED HEALTH BENEFITS, REPEAT A MANTRA QUIETLY EACH TIME YOU DRAW A NEW LINE. YOU CAN TRY: LAM, VAM, RAM, YAM, HAM, OR OM. THESE ARE BIJA MANTRAS AND ARE RELATED TO YOUR ENERGY CENTERS.

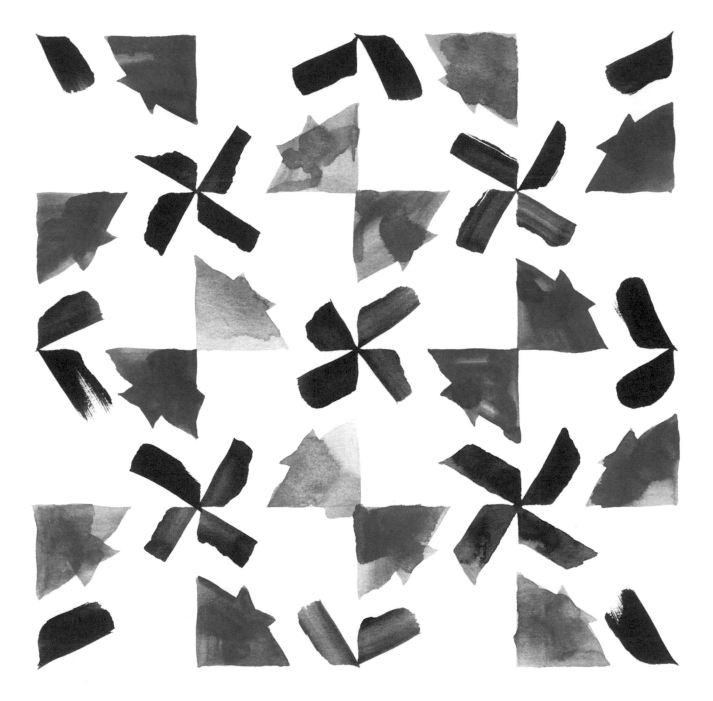

Draw a grid with a pencil, making squares of equal size. Sketch on one of the squares the elements you want your pattern to have. Repeat these motifs across the page to the right, but rotate the pattern by 90 degrees each time. Keep rotating and sketching until you have a tile-like repeating pattern. Try using a dagger brush and watercolor.

**TIP:** IF YOU WANT TO TRY A MORE COMPLEX DESIGN, IT MAY BE HELPFUL TO TRACE THE MOTIF WITH CARBON PAPER ON EACH OF THE SLOTS. JUST REMEMBER TO ALWAYS ROTATE THE MODULE BEFORE REPEATING A MOTIF!

# MOUNTAIN CHAIN

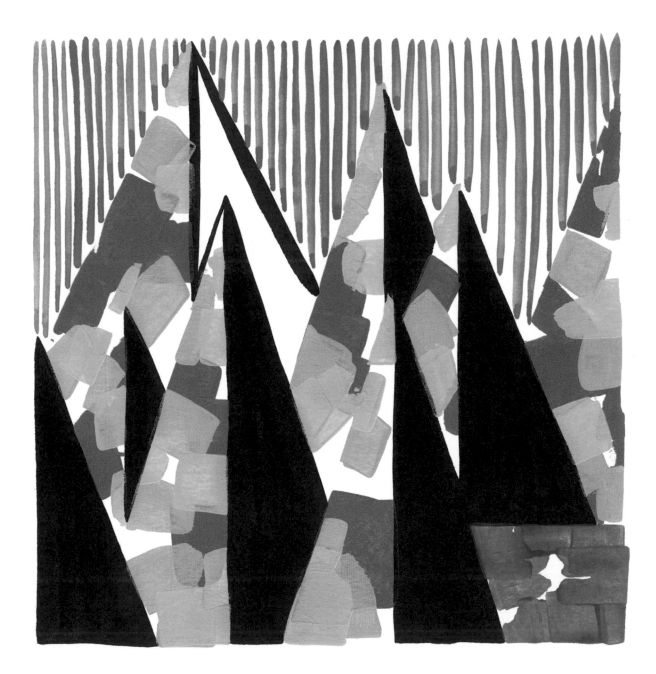

PAINT HERE
↘

You can apply paint with whatever tool you have around. Brushes are not always necessary. For this exercise, use a paint scraper to spread acrylic paint. It's very easy to do: Just dip the tip of your painting knife or scraper in acrylic paint or gouache and then drag it over the surface of the paper. This method will give your artwork a more textured look.

---

**TIP:** TO MAKE THE AREAS YOU CREATED WITH THE SCRAPER STAND OUT MORE, GIVE THE REST OF THE MOTIFS A SIMPLE LOOK WITH NEUTRAL SOLID COLORS, SUCH AS THE BLACK HALVES OF THE MOUNTAINS IN THIS EXERCISE.

DRAW HERE

Draw your favorite letter or symbol with a pencil. You don't need to draw anything fancy, just the shape of the structure you want your drawing to have. Start sketching shapes, objects, or anything around it as long as you keep the original shape.

**TIP:** TRY USING A MEDIUM-SIZED ROUND BRUSH AND HIGHLY PIGMENTED LIQUID ACRYLIC. THE ORIGINAL OUTLINE/SKETCH FOR THIS EXERCISE WAS DONE WITH A 2B PENCIL AND ERASED AFTER THE ACRYLIC WAS DRY.

# PAINTING WITH FABRIC

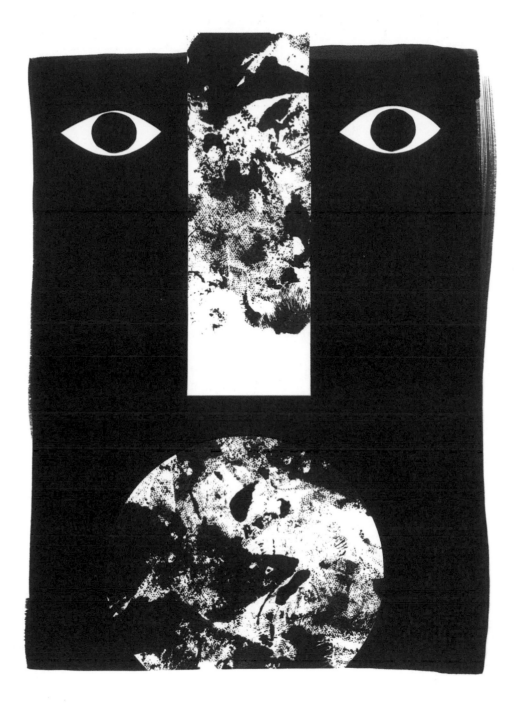

For this exercise, dip a crumpled-up piece of cotton fabric into black acrylic paint and use it as a stamp on a piece of paper. When the texture is dry, cut the paper into different shapes. On another piece of paper, paint a simple black gouache rectangle and glue on the cut textured pieces to create a face.

**TIP:** THERE ARE MANY GLUES OUT THERE THAT ARE GOOD FOR COLLAGE WORK, BUT I'M ESPECIALLY FOND OF NATURAL ONES, SUCH AS COCCOINA. THEY WORK GREAT AND ARE NONTOXIC—GOOD FOR YOU AND THE ENVIRONMENT!

# GARLANDS

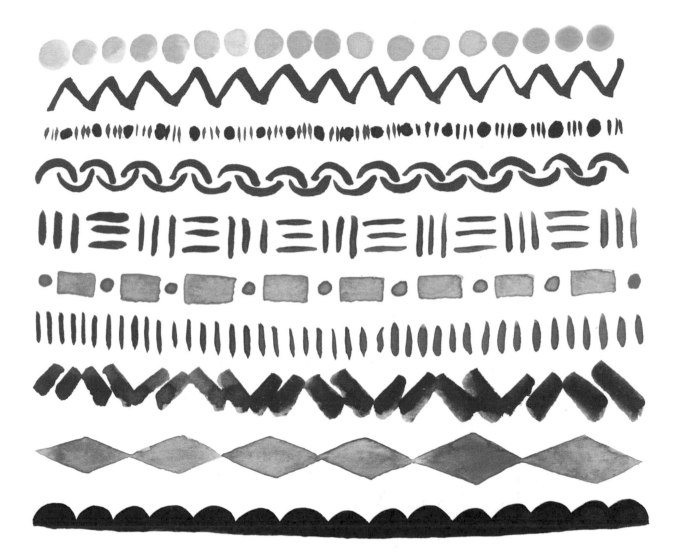

Adorn your paper with as many garlands as you can think of. They don't need to be perfect, nor do they need to be too fancy. Sometimes a simple line is more powerful than a complex drawing. Try playing with different colors to give it a festive look!

**TIP:** TRY DIFFERENT BRUSHES TO ACHIEVE DIFFERENT RESULTS. A FILBERT BRUSH WILL GIVE YOU A SMOOTH FEEL WHILE A FLAT BRUSH CAN GIVE YOU AN INTERESTING VARIABLE THICKNESS DEPENDING ON THE ANGLE YOU USE.

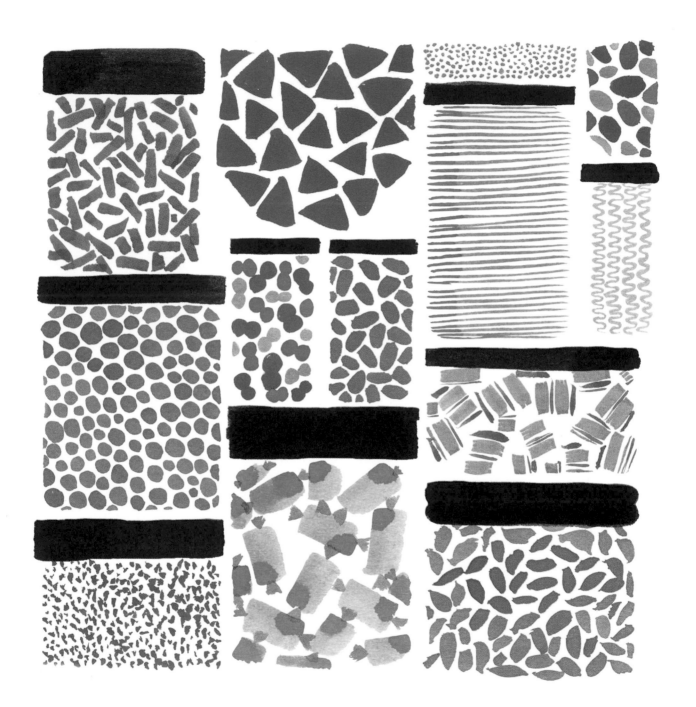

PAINT HERE

This experiment is about creating an abstract candy collection. The jar lids were done with a flat brush and ink—bold and minimal. The sweets were done with watercolor using both flat and round brushes.

**TIP:** THE USE OF BRIGHT HUES HERE IS KEY FOR THE BRUSHSTROKES TO LOOK LIKE CANDY. DON'T BE SCARED TO PUMP UP THE COLOR.

# FAN BRUSH PRINT

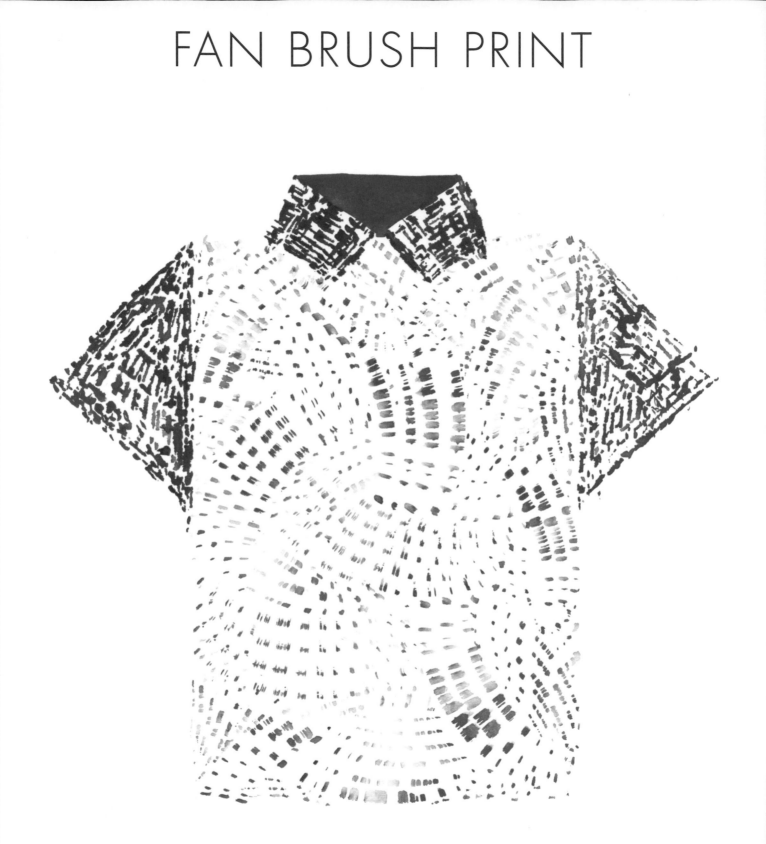

Apply textures on a shirt silhouette with a fan brush. This kind of brush is great for delicate work. The collar and sleeves are done by positioning the brush perpendicular to the paper. Tilt the brush 45 degrees for the central area.

**TIP:** FOR A GRADIENT COLOR LOOK, DIP HALF OF YOUR BRUSH INTO A GREEN WATERCOLOR PUDDLE AND THE OTHER HALF INTO BLUE. USE THIS TECHNIQUE WITH YOUR BRUSHES TO MAKE RAINBOW WASHES!

# FLOWER ARRANGEMENT

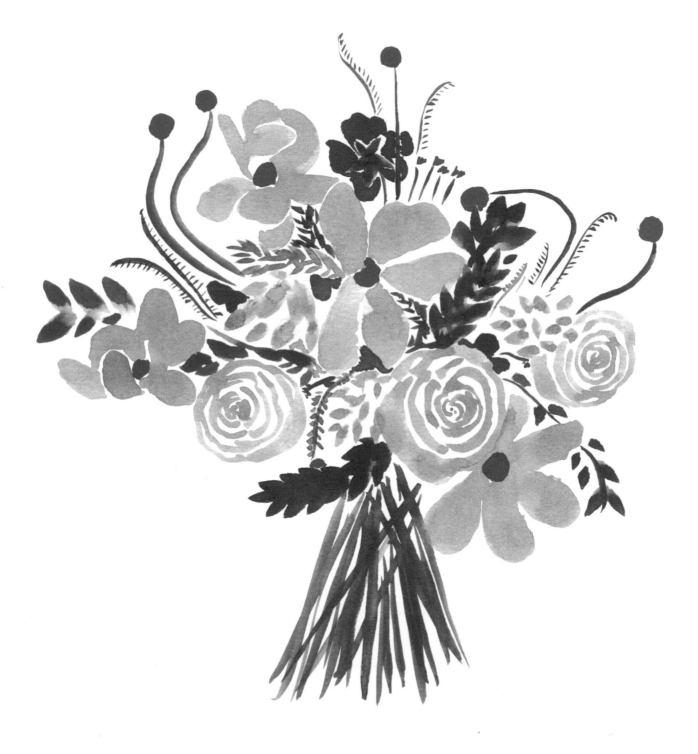

PAINT HERE

This exercise is a wonderful excuse to buy yourself some flowers. Study the arrangement and sketch the flowers with a pencil first. You don't need to sketch them in detail, just capture a few shapes and apply several watercolor washes to convey their impression. Don't pressure yourself with the results, just enjoy the process.

**TIP:** A NICE PALE PINK SHADE IS HARD TO FIND IN WATERCOLOR SETS, SO I MIX ONE WITH PLENTY OF WHITE, A TOUCH OF YELLOW AND MAGENTA, AND A DROP OF BLACK. (LASCAUX HAS AN AMAZING SET WITH WHICH TO MIX YOUR OWN COLORS.)

# SHADOWS

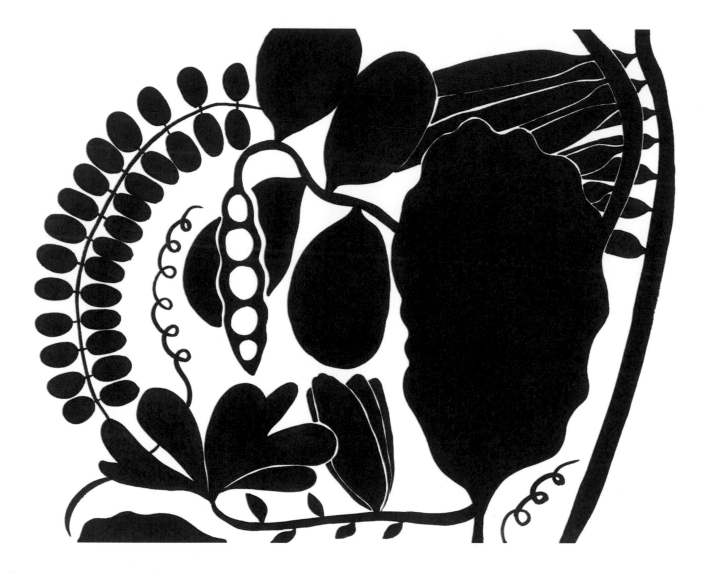

Forget the details and focus only on the outlines of the elements you want to paint. Try sketching first with a pencil and then cover the drawing with black ink or any other paint you may prefer. Observe the composition: Do you want to add more elements, or would you prefer to just focus on a branch, for example?

**TIP:** IF YOU WANT TO DRAW THE SILHOUETTES OF A STILL LIFE ARRANGEMENT OR AN OBJECT IN FRONT OF YOU, PLACE A LIGHT BEHIND IT TO MAKE ITS CONTOURS CLEARER. AN ANGLEPOISE LAMP WOULD BE PERFECT FOR THIS EXERCISE.

# SPONGE TEXTURES

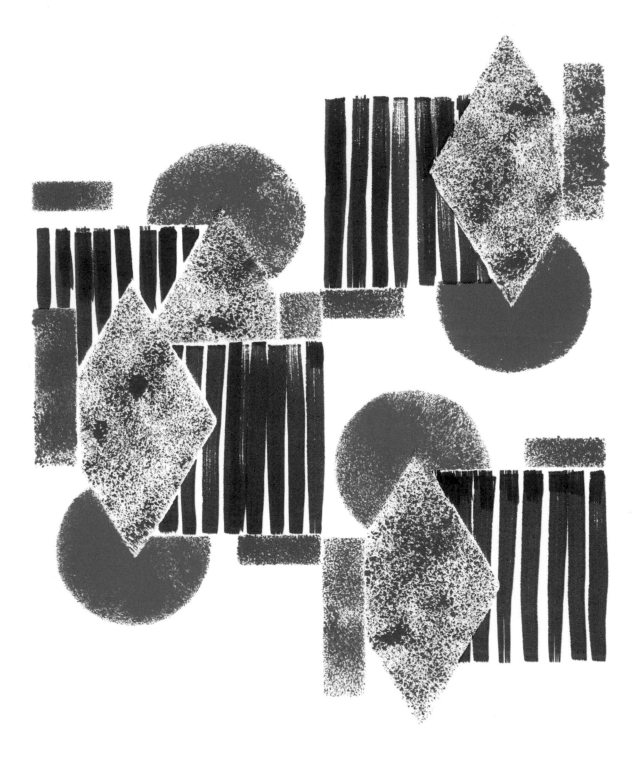

PAINT HERE

Start by making some stencils. Cut a few simple shapes out of card stock, one for each color in the final image, and then use a sponge dipped in acrylic paint to print the shapes onto paper. Try forming the black lines with ink and a flat brush.

**TIP:** APPLY PAINT TO A SPONGE WITH YOUR BRUSH SO THAT YOU DON'T APPLY TOO MUCH PAINT, LOSING CRISPNESS AND TEXTURE. A FEW STROKES OF PAINT CAN GO A LONG WAY!

# WOODEN PUZZLE

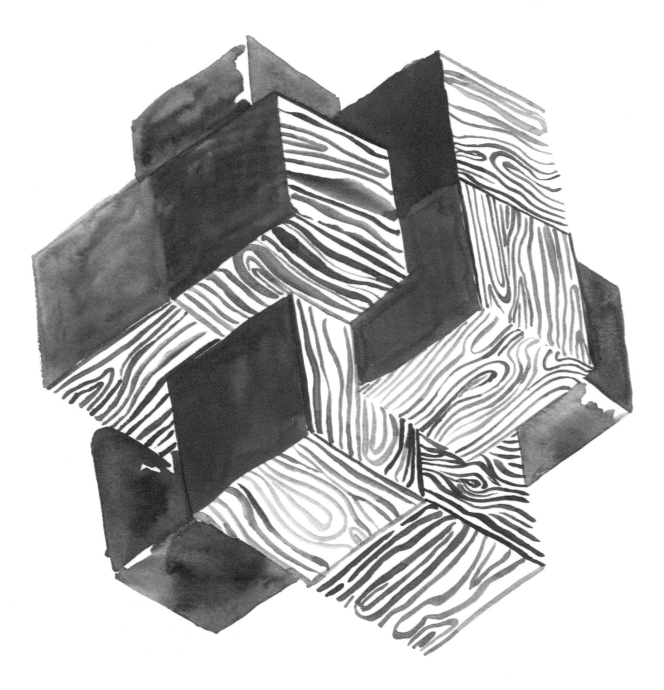

PAINT
HERE

A ruler set comes handy for this exercise because parallel lines are always cleaner and better looking with the help of a set square. Decide where the light would be coming from on your drawing and which areas would be lighter and which would be darker. Try sketching this first with pencil and then color with watercolor.

**TIP:** FOR THE GRAIN OF THE WOOD, USE A THIN, MEDIUM-SIZE ROUND BRUSH. DON'T BE TOO CONCERNED ABOUT THE CURVES AND KNOTS, JUST MAKE CURVED LINES WITH A WOOD-LIKE COLOR AND IT WILL LOOK PRETTY "WOODISH."

# PLAYING CUBISM

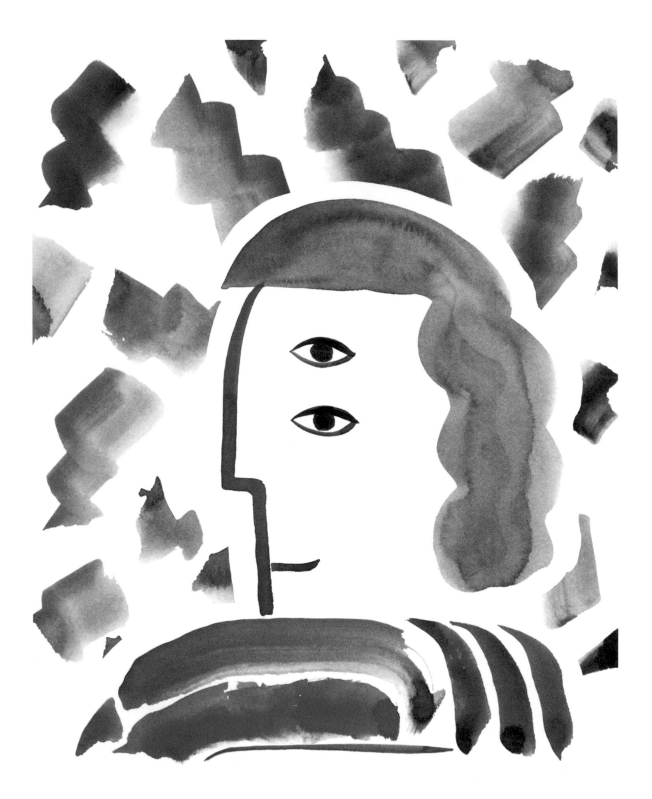

Channel your inner Cubist painter and paint something with an impossible perspective as if you were looking at it from different points of view at the same time. Don't try to be too representational. Just play and plan wacky perspectives.

**TIP:** MAKE THE "HALO" AROUND THE FIGURE WITH LIQUID FRISKET. USE AN OLD BRUSH TO APPLY IT AND LET IT DRY BEFORE PAINTING ON TOP. WHEN FINISHED, REMOVE THE FRISKET BY RUBBING IT WITH YOUR HANDS.

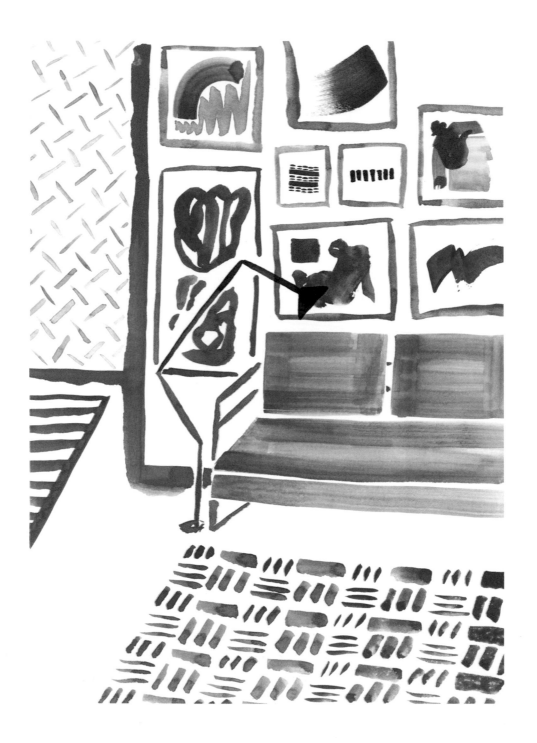

Create a Matisse-inspired room scene using primary colors and simple patterns. Use a medium-size round brush for all the elements in this exercise except for the sofa, for which you can use wide flat brush. Feel free to experiment and go monochromatic or play with muted colors.

**TIP:** DON'T WORRY TOO MUCH ABOUT GETTING THE PERSPECTIVE EXACTLY RIGHT. A SLIGHTLY AWKWARD PERSPECTIVE GIVES DRAWINGS A PLAYFUL AND FRESH TOUCH. NOT TRYING TOO HARD TO BE TOO ACCURATE CAN BE LIBERATING!

# ABOUT THE ARTIST

Ana Montiel is a London-based Spanish visual artist and designer. She works with a wide range of materials and media, from screen printing to ceramics, surface design, installation, and collage. Her influences are as diverse as David Lynch and his holistic approach to creativity, Carl Jung's *Red Book*, vintage educational charts, the arts and crafts movement, astrology, and ayurveda.

Ana also works as an illustrator, art director, and designer and has collaborated with the likes of John Legend, Nina Ricci, Jo Malone, Carolina Herrera, and Anthropologie.

She has her own wallpaper line, the first design of which was selected as a "key product to watch" in the *New York Times*.

Her artwork has exhibited in Europe and North America, and she has been featured in international digital and print media such as *Grand Designs*, *Elle Interiör*, and *El País*.

© 2015 by Quarry Books

First published in the United States of America in 2015 by
Quarry Books, a member of
Quarto Publishing Group USA Inc.
100 Cummings Center
Suite 406-L
Beverly, Massachusetts 01915-6101
Telephone: (978) 282-9590
Fax: (978) 283-2742
www.quarrybooks.com
**Visit www.craftside.net for a behind-the-scenes peek at our crafty world!**

10 9 8 7 6 5 4 3 2 1

ISBN: 978-1-63159-046-7

Digital edition published in 2015
eISBN: 978-1-62788-339-9

**Library of Congress Cataloging-in-Publication Data available.**

Cover and design: Ana Montiel and Tea Time Studio

Printed in China